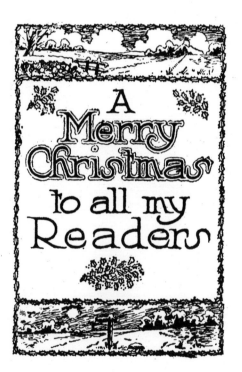

A
Merry
Christmas
to all my
Readers

THE
CHRISTMAS
BOOK

Edited by David Larkin

CHARLES SCRIBNER'S SONS
New York

An original PEACOCK PRESS/BANTAM BOOK

THE CHRISTMAS BOOK

Copyright 1975 in all countries of the International Copyright Union
by Bantam Books, Inc. All rights reserved.

Library of Congress Catalog Card Number: 75-11193
Hardcover ISBN 0-684-14417-4

PRINTING HISTORY
First U.S. Edition: August, 1975
Hardcover Edition: August, 1975

Hardcover edition published by Charles Scribner's Sons,
by arrangement with Peacock Press, a division of Bantam Books, Inc.

Published simultaneously in the United States and Canada

PRINTED IN ITALY BY MONDADORI, VERONA

This is, with some exuberant exceptions, a collection of illustrators' work showing how they have responded to the theme of Christmas as set to them by others. The work falls within a period from the turn of the century to just into the fifties, and stops there because Christmas is best a memory. Although the demand for nostalgia accelerates, it would be better if contemporary work on this theme was looked at another day.

The artists in this book had to look back anyway. They often worked in the heat of summer to meet deadlines set by publishers who advanced Christmas as much as any other trader. Hence the contrast: snow is everywhere.

The publishing and bookselling businesses have certain periods of increased activity, one of the busiest periods being the three months or so before Christmas and, in Britain, the built-in 'sale' time that follows immediately after. At that time we can hope to purchase what we really wished to receive, for less money. In the summer the booksellers get themselves organized for what they think the public would like to give itself. They ask the publishers, 'What have you

got for Christmas?' Out come the gift, or coffee-table books. And now we have the paperback version, reaching an even wider public with its greater number of outlets and its lower cost. With the noticeable improvement in its production standard the paperbound gift book has become a marvelous vehicle for showing the color and graphics of both past and present.

While organizing and designing the other books in this series I had often given thought to combining the work of some of the artists who have become forgotten and unfashionable with that of their more successful contemporaries and others who are still with us and working busily. Examples of one artist's work lead to another's, and the theme of Christmas linked them.

Some of the research took me to Cleveland, and in the Public Library there I was able to look through thousands of periodicals and concentrate on end-of-the-year issues. The illustrators had mirrored the changing times in their work, injecting humor in times of stress and reflecting the quality of life in times of peace and prosperity. And, looking along the

rows of bound volumes, I could see from this century's beginning magazines being in themselves an illustration of the last seven decades. Modest at first, growing fat and strong with advances in printing, color and advertising, becoming temporarily slim during the Depression, picking themselves up, in the recent past changing size, amalgamating, and then dying from the relentless onslaught of the video, becoming even smaller than at their birth.

But the Christmas numbers were always fat and the illustrators were kept busy. Delivering newspapers and magazines as a boy in East London, I remember during the Christmas week how much heavier the bag used to be, and of course reading what I was delivering I was amazed to see how in just one issue the whole presentation changed. There was more of everything and, apart from the inevitable snow-capped lettering, the artists used the opportunity to get more fun and activity into their regular allocated space. Borders, pictorial puzzles and caricatures abounded, giving an extra measure of joy where the artists may have been asked merely to show a few bells and some holly to mark the holiday.

The artists were really just doing honest work for reproduction, the originals of which survived only briefly in dusty basements before being cleared out. In many cases, nobody honestly knew what to do with them. Thankfully, today most illustrators get their work returned to them after use. Today also the printing process can, with care, achieve a reproduction taken from work printed long ago that is so faithful that even the artist would have been pleased with the result, as it is often better than was originally hoped for.

These people succeeded in creating atmosphere, knowing that at Christmas time some folks return to the hearth and others go away hoping to find a convivial family feeling elsewhere. Many thought then that the Dickensian view was the right one; coaches plowing through snow, log fires indoors, fat little men and ladies wearing bonnets were steady Christmas-card sellers (and are still) in the English-speaking world. The reality everyone knew was a lot less cozy than even in the Cratchit home. Things change – in the future there may be a Rockwellian view of the season. But Norman and his contemporaries broke new

ground and picked as their subjects the bustle, the preparation, the *work* of Christmas, showing the social effect of the build-up and the gift wrapping. They, with great insight and sympathy, illustrated the point that the public gets its greatest enjoyment of Christmas from anticipation and the spontaneous moment of unwrapping.

In fact these illustrators have contributed to making the magazines into a holiday program of events, supplying ideas to keep everyone busy. So, too, the viewer of these illustrations sees in some of them the Anglo-Saxon sense of humor, and perhaps we sense that we are on the receiving end of the artist's favorite Christmas card.

Here we are then. This is a minority report with a graphic view that can never expect to be successfully agreed upon after the holiday. It endeavors simply to make the festival and the time before it enjoyable.

Merry Christmas.

David Larkin

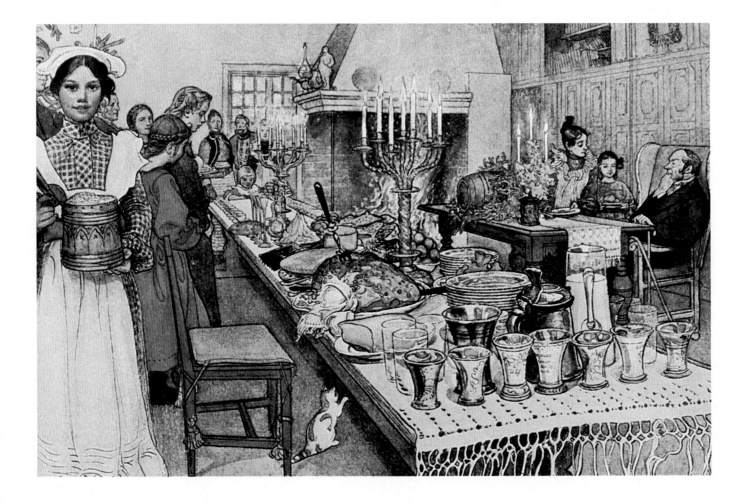

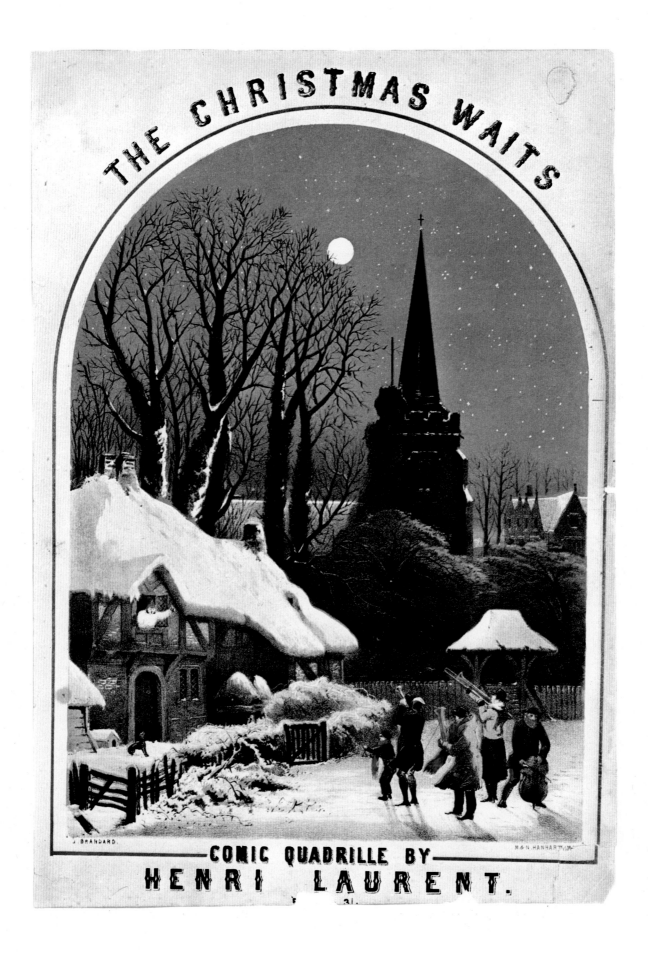

THE CHRISTMAS WAITS

COMIC QUADRILLE BY

HENRI LAURENT.

2) Music Sheet: The Christmas Waits.
J. BRANDARD

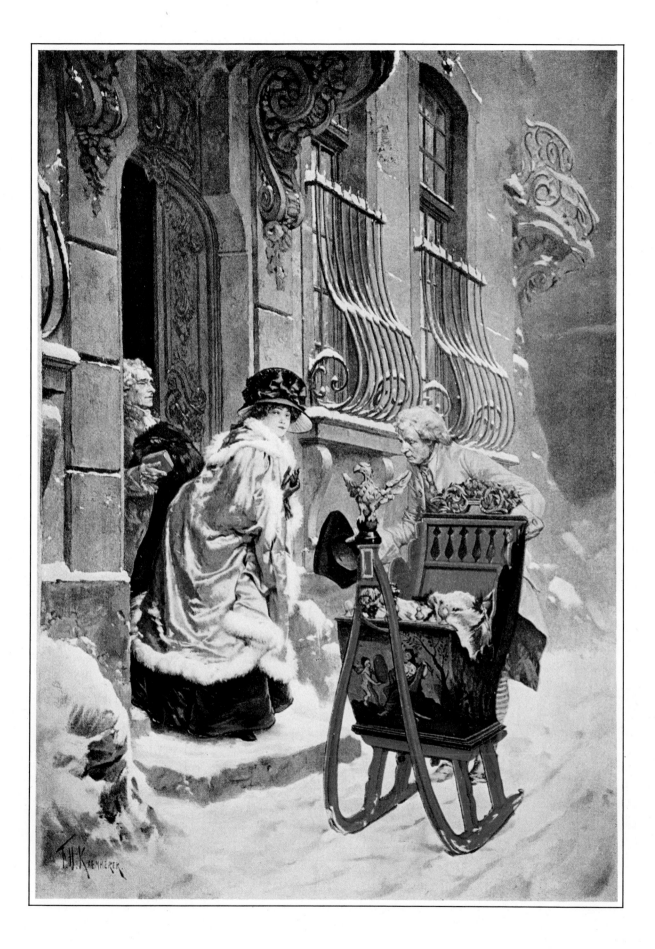

3) Going to Midnight Mass.

F. H. KAEMMERER

1902

FIGARO ILLUSTRE

British Library, London

Photo – M. Slingsby

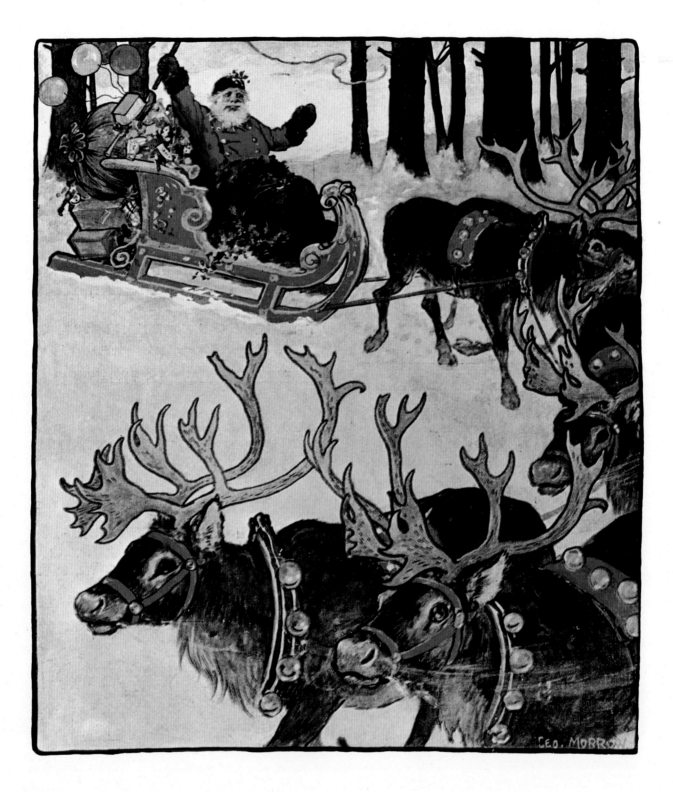

4) Santa and Reindeer
GEORGE MOBROW
THE SPHERE
1903
Arts Decoratifs, Paris
Photo – J. Hyde

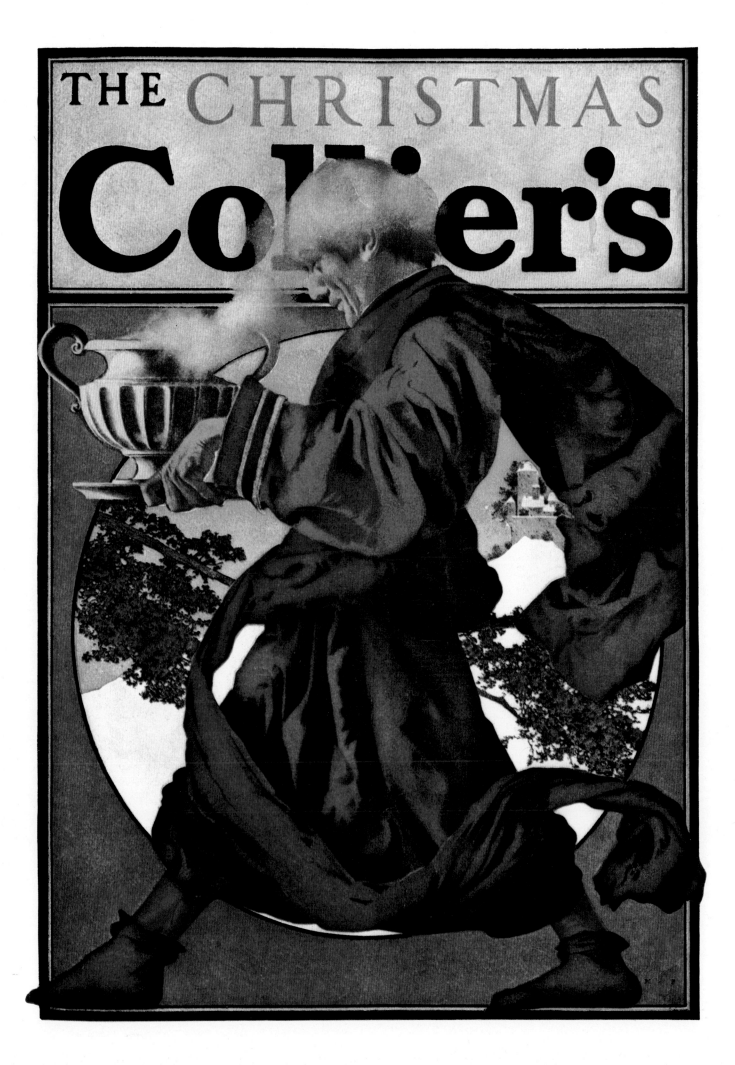

5) The Wassail Bowl
MAXFIELD PARRISH
COLLIER'S
December 1909
Cleveland Public Library
Photo – M. Varon
© 1909 Maxfield Parrish

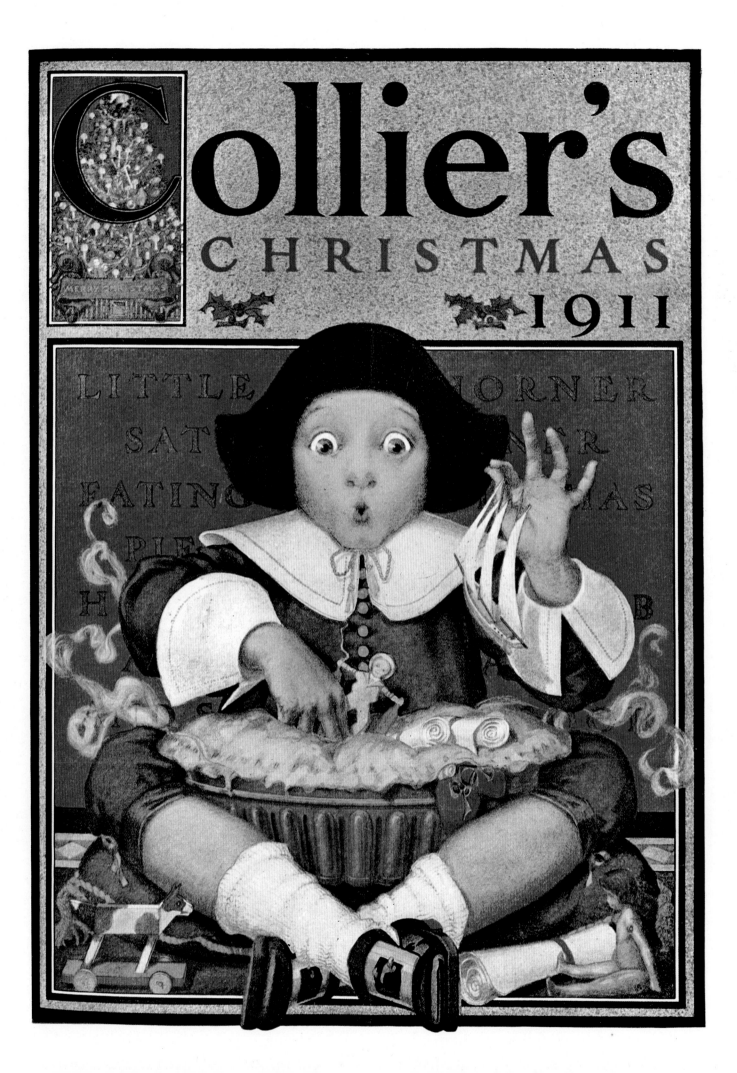

6) Little Jack Horner.
E. STETSON CRAWFORD
<small>COLLIER'S</small>
December 1911
Cleveland Public Library
Photo – M. Varon
© 1911 Crowell-Collier Pub. Co.

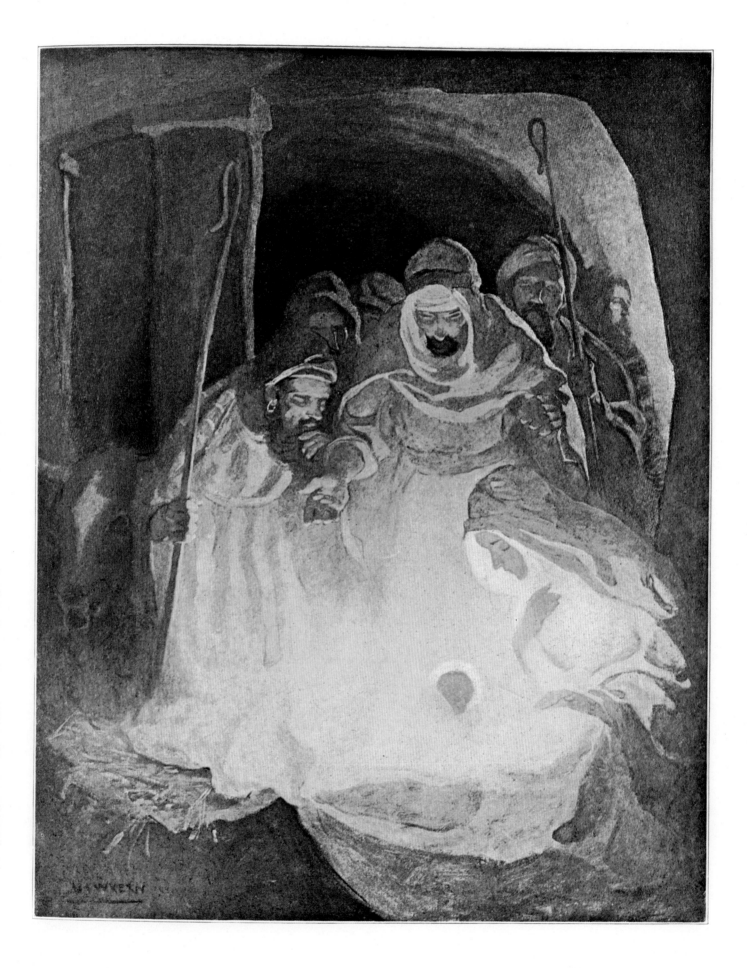

7) It was, then, not a dream.
 N. C. WYETH
 SCRIBNER'S
 December 1912
 Cleveland Public Library
 Photo – M. Varon

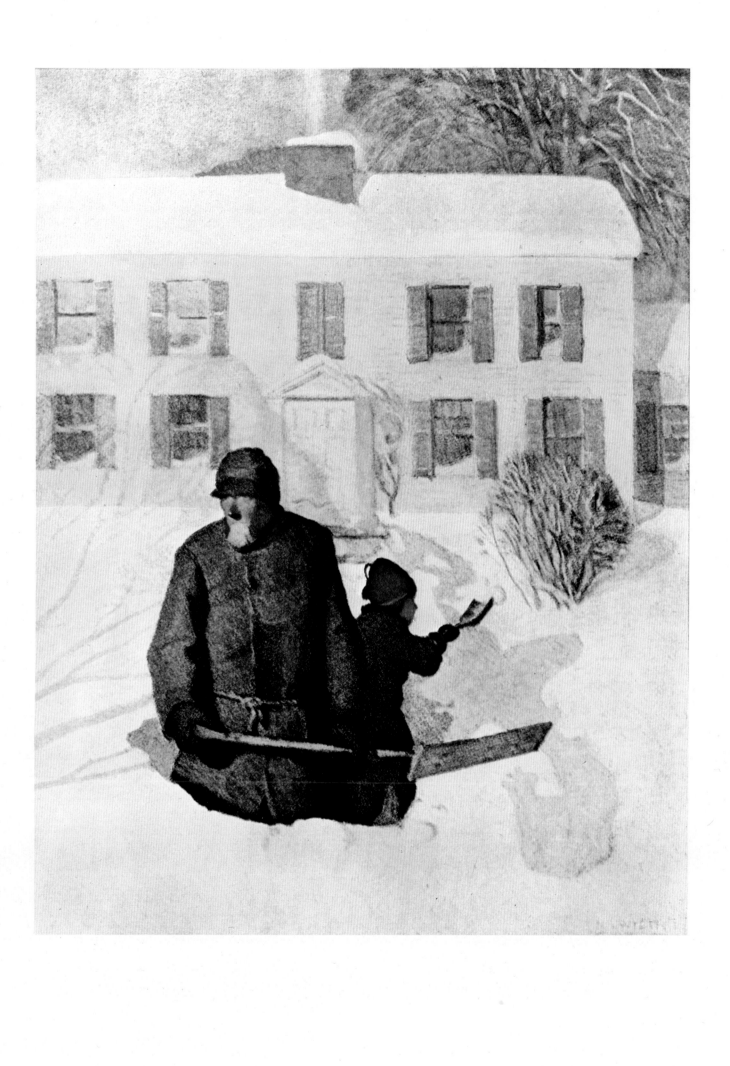

8) Christmas Morning
 N. C. WYETH
 SCRIBNER'S
 December 1913
 Cleveland Public Library
 Photo – M. Varon

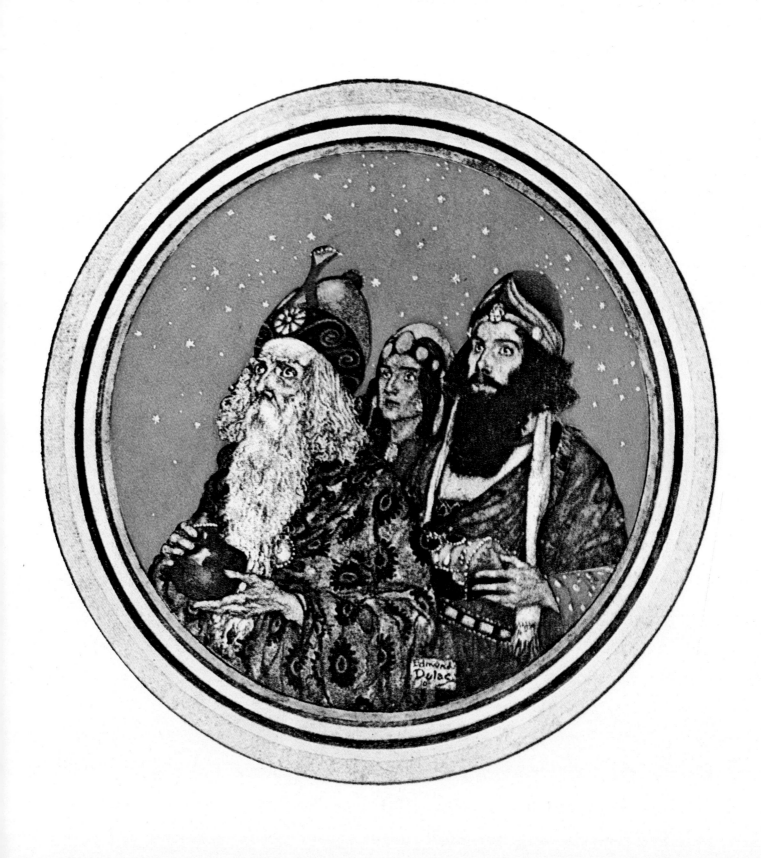

9) O Star of Wonder, Star of Night
EDMUND DULAC
Edmund Dulac's Picture Book

HODDER & STOUGHTON, LONDON

Photo – J. Warren

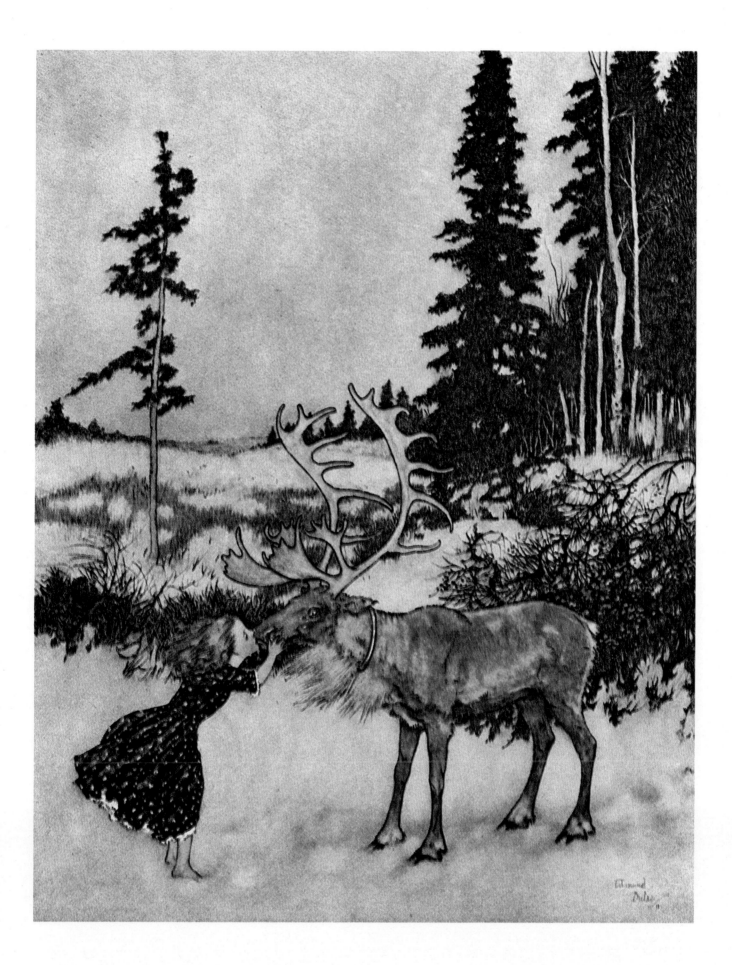

10) The Reindeer did not dare to stop. It ran till it came to the bush with the red berries. There it put Gerda down, and kissed her on the mouth, while big shining tears trickled down its face.

EDMUND DULAC

The Snow Queen

Stories from Hans Anderson

HODDER & STOUGHTON, LONDON

Photo – J. Warren

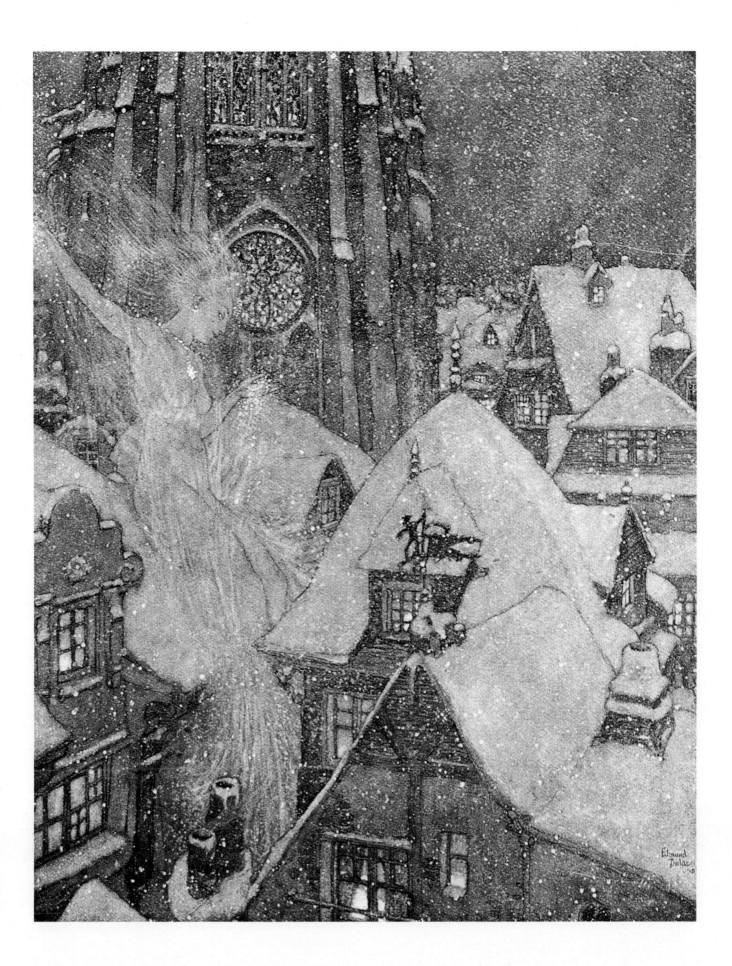

11) Many a winter's night she flies through the streets and peeps in at the windows, and then the ice freezes on the panes into wonderful patterns like flowers.

EDMUND DULAC

Stories from Hans Anderson

HODDER & STOUGHTON, LONDON

Photo – J. Warren

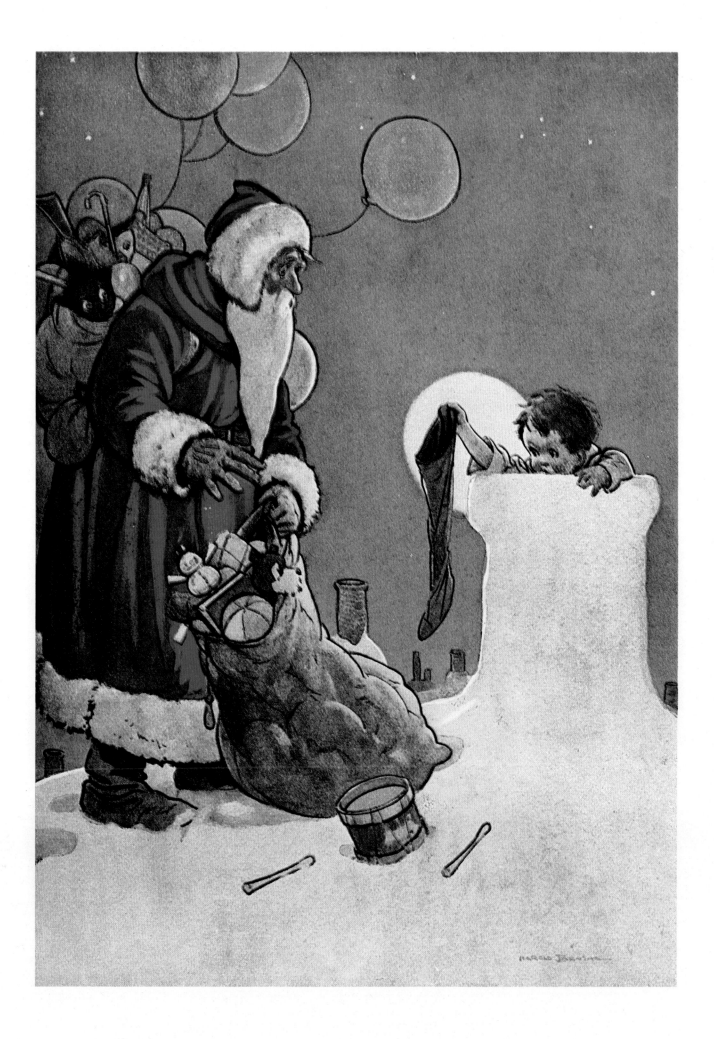

12) The Hold up!
HAROLD FARNSAL
LITTLE FOLKS
British Library, London
Photo – M. Slingsby

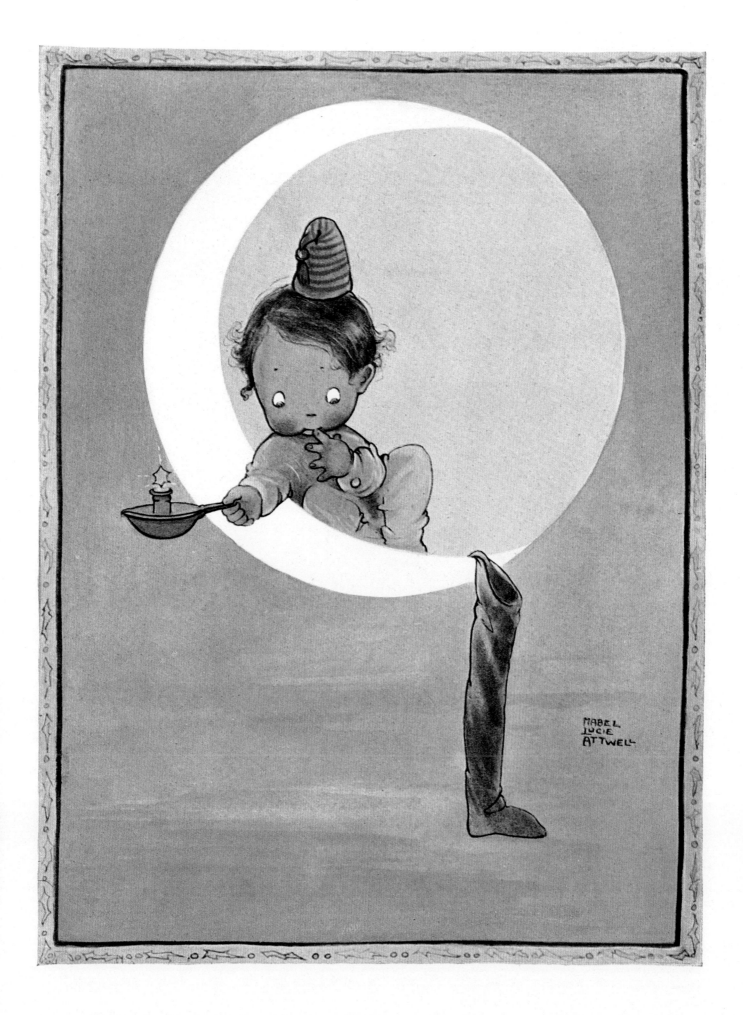

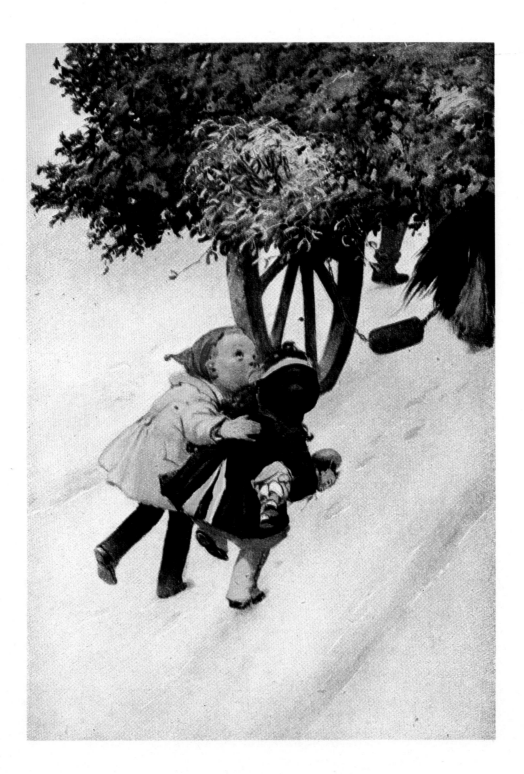

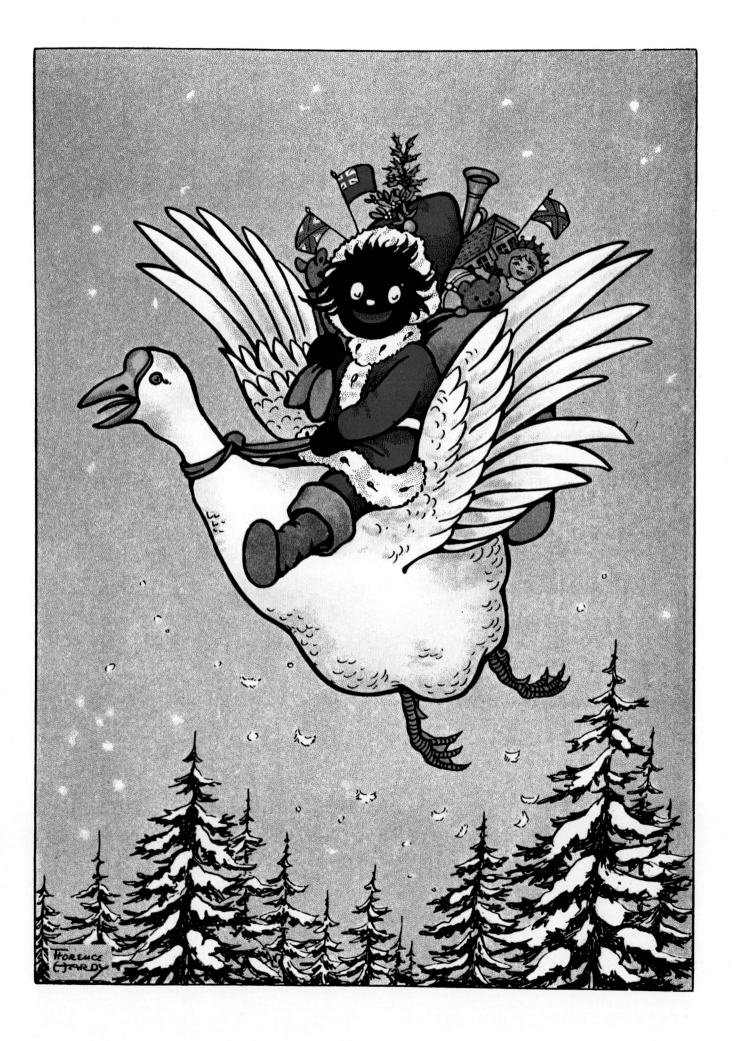

15) Gollywog's Christmas
FLORENCE HARDY
LITTLE FOLKS
British Library, London
Photo – M. Slingsby

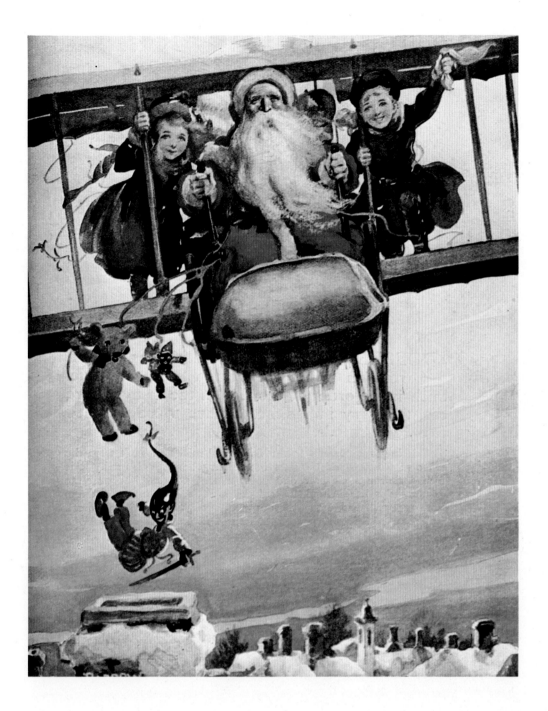

16) Santa's Aeroplane
BARROW
LITTLE FOLKS
December 1916
British Library, London
Photo – M. Slingsby

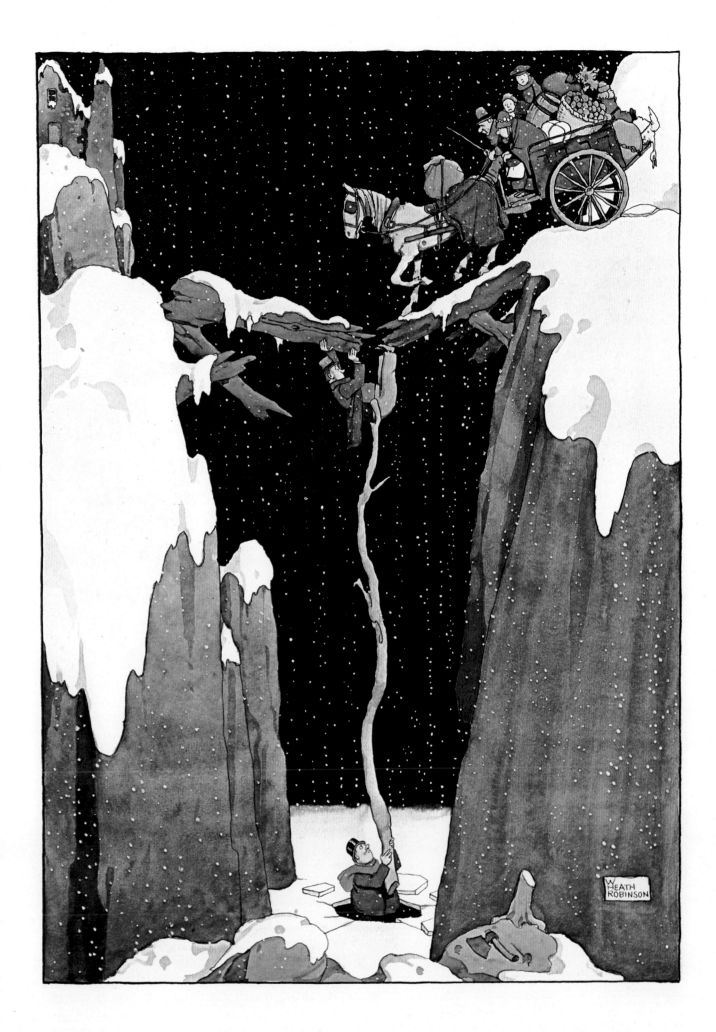

17) A Deed of Christmas Kindness.
W. HEATH ROBINSON
HUTCHINSON'S MAGAZINE
Constable & Co., London

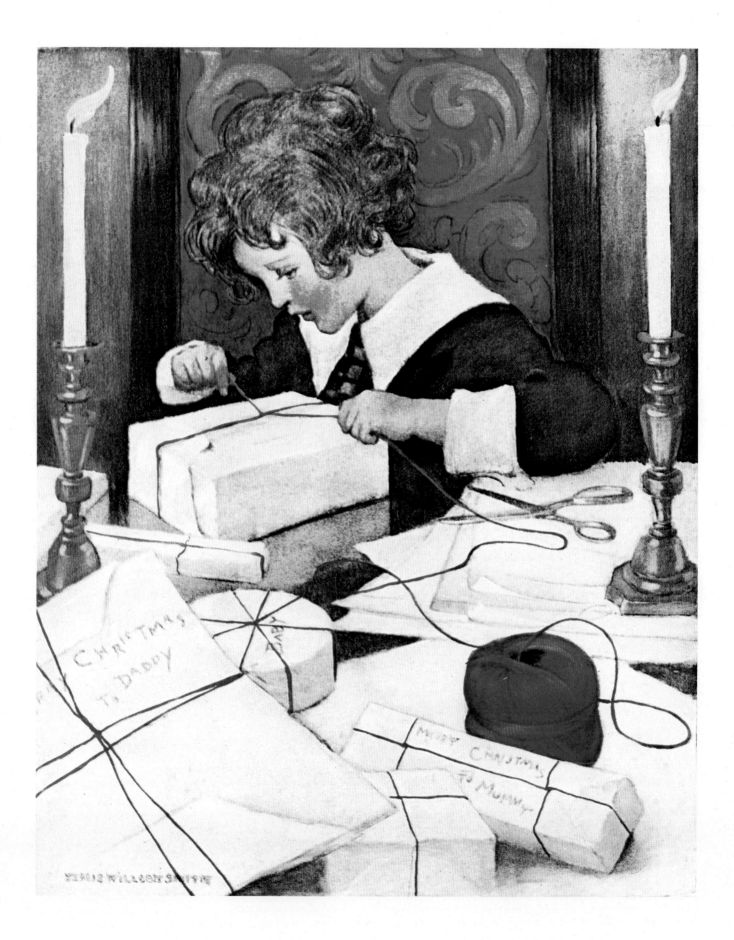

18) My Ball of Twine

JESSIE WILLCOX SMITH

WOMAN'S HOME COMPANION

December 1919

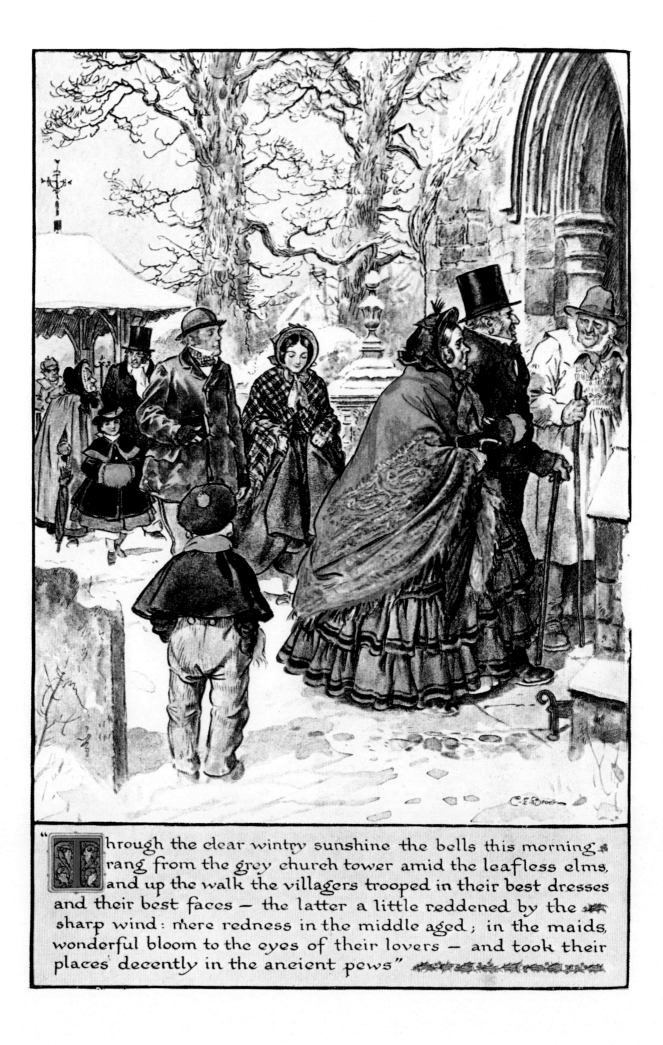

"Through the clear wintry sunshine the bells this morning rang from the grey church tower amid the leafless elms, and up the walk the villagers trooped in their best dresses and their best faces — the latter a little reddened by the sharp wind: mere redness in the middle aged; in the maids, wonderful bloom to the eyes of their lovers — and took their places decently in the ancient pews"

19) Christmas at Dreamthorpe.

C. E. BROCK

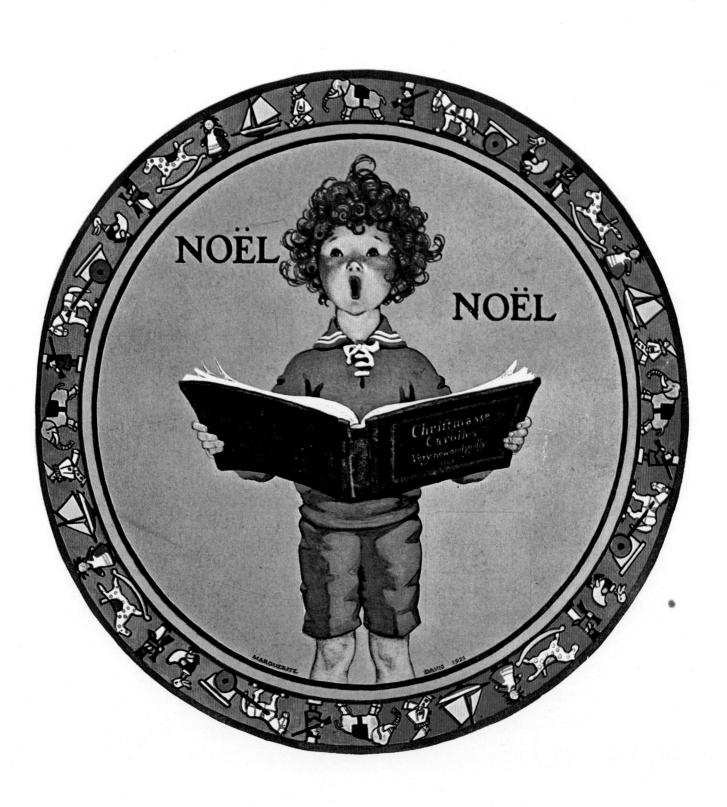

20) Noël, Noël
MARGUERITE DAVIS
WOMAN'S HOME COMPANION
December 1921
British Library, London
Photo – M. Slingsby

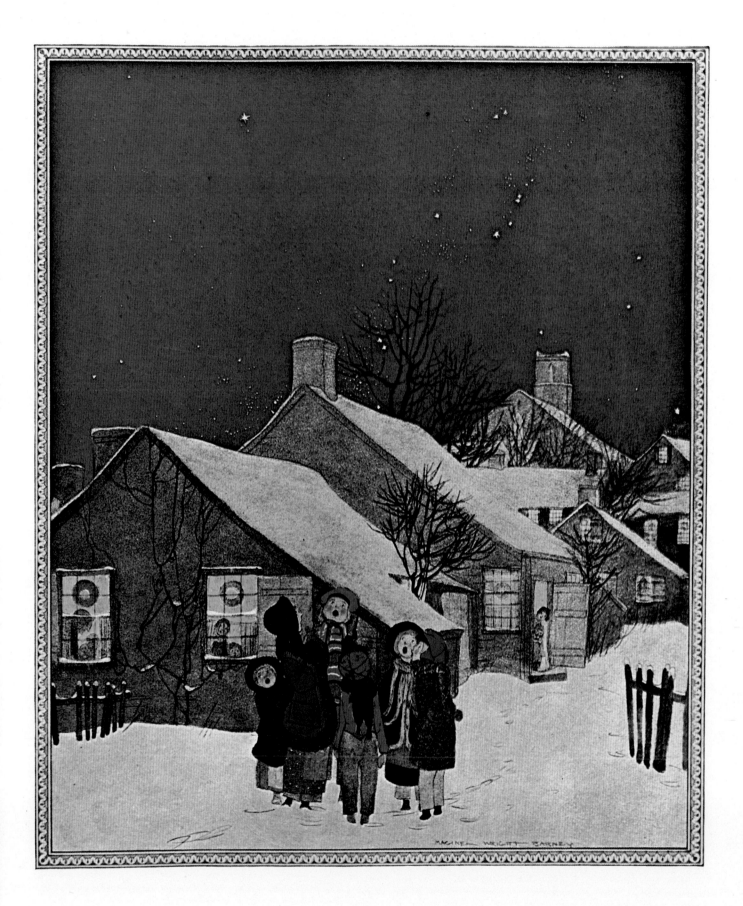

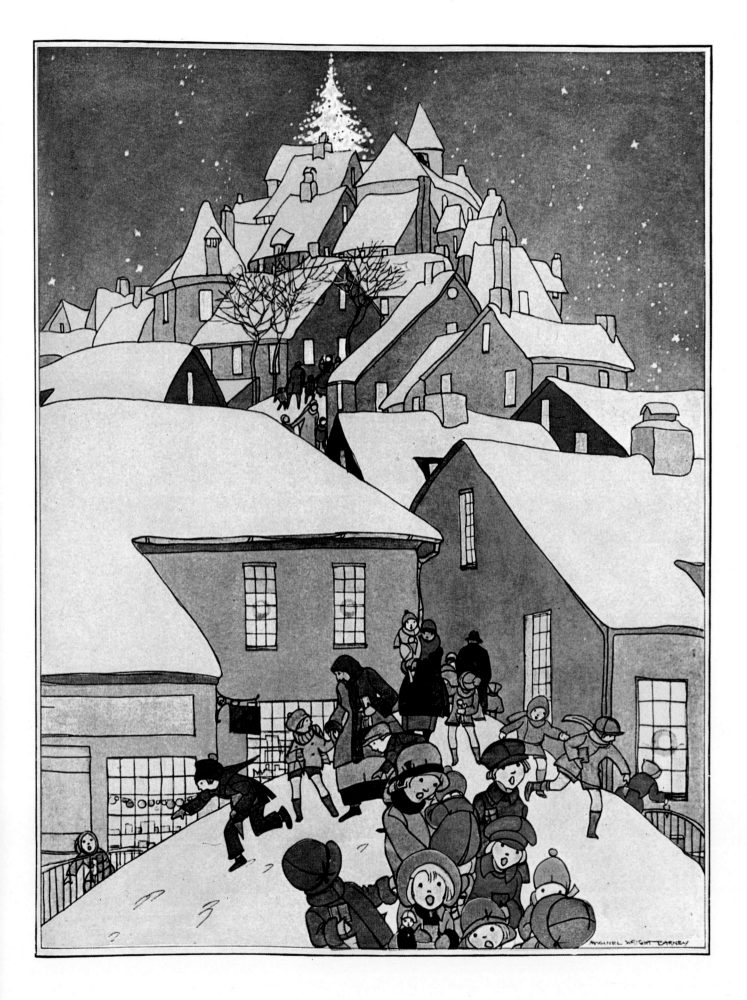

22) Christmas Frolics

MAGINEL WRIGHT BARNEY

WOMAN'S HOME COMPANION

December 1928

British Library, London

Photo – M. Slingsby

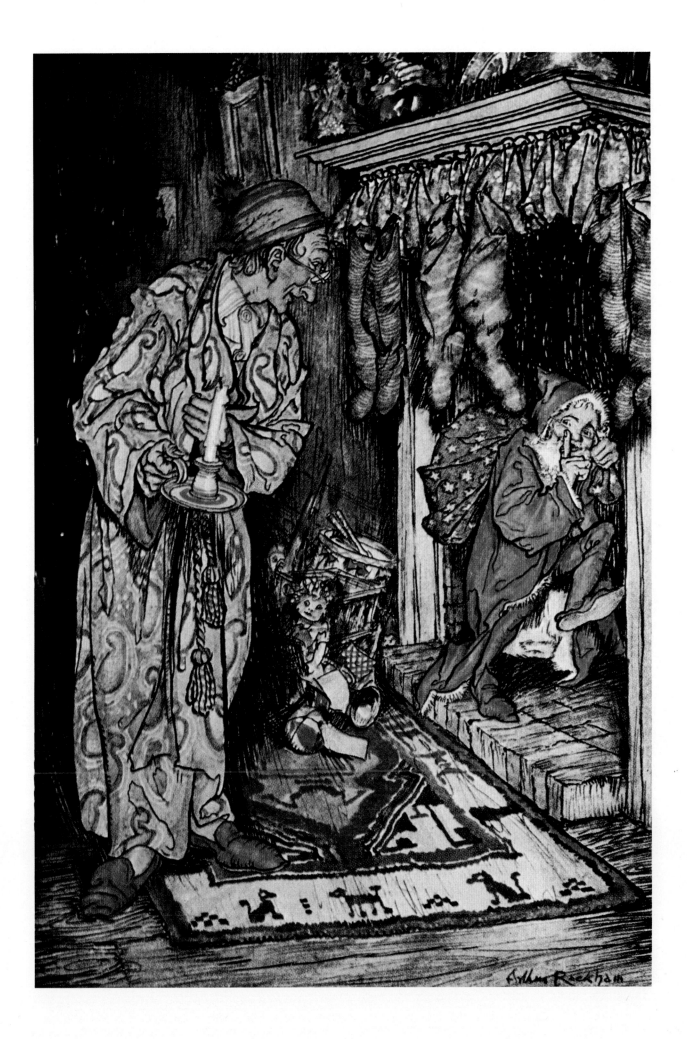

23) "And giving a nod, up the chimney he rose."
ARTHUR RACKHAM
The Night Before Christmas
by C. Clement Moore
1931
GEORGE G. HARRAP & CO., LONDON
Photo – J. Warren

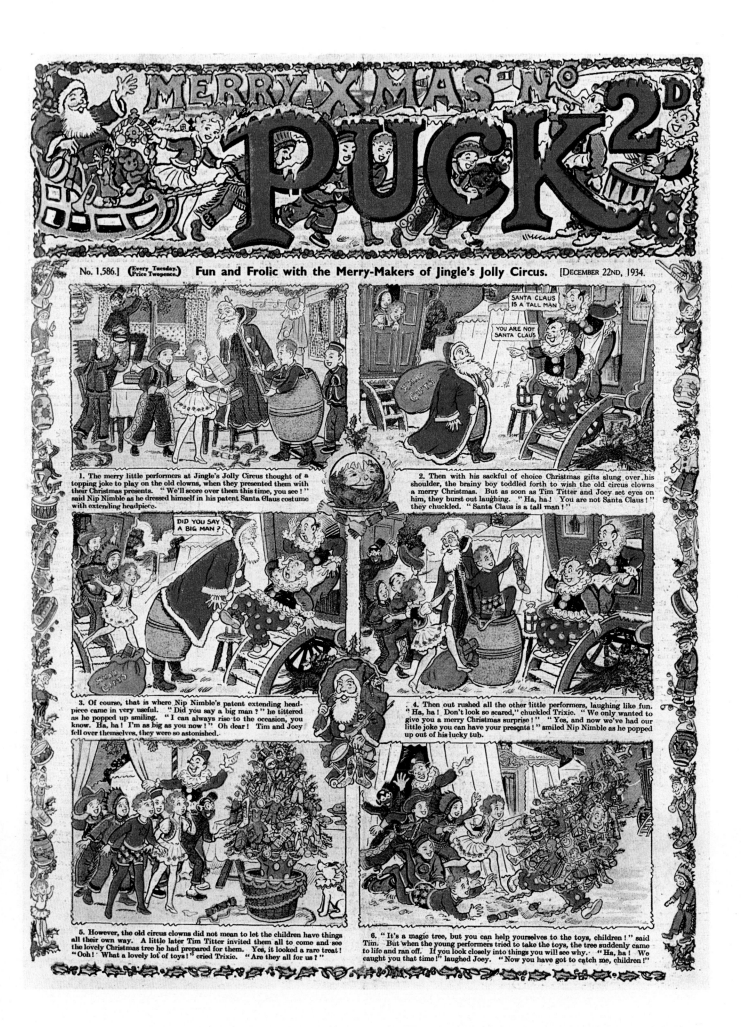

24) Puck
22 December 1934
IPC PUBLISHERS, LONDON

Photo – M. Slingsby

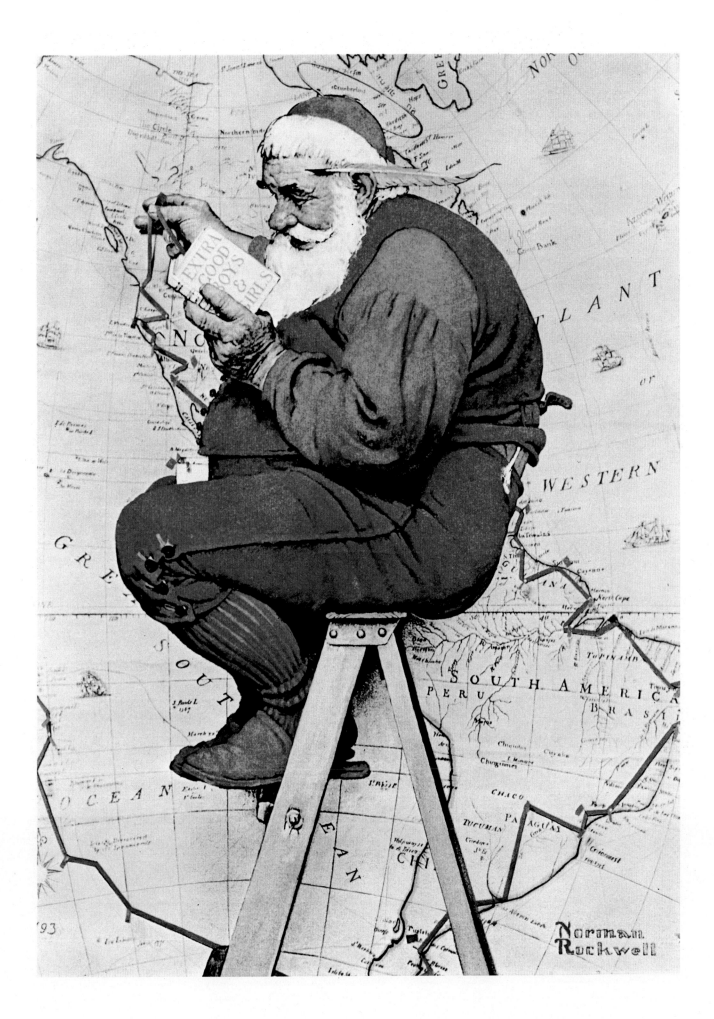

26) Santa Taping Route Map

NORMAN ROCKWELL

THE SATURDAY EVENING POST

December 1939

Cleveland Public Library

Photo – M. Varon

Reprinted with permission from
THE SATURDAY EVENING POST
© 1939 The Curtis Publishing Company

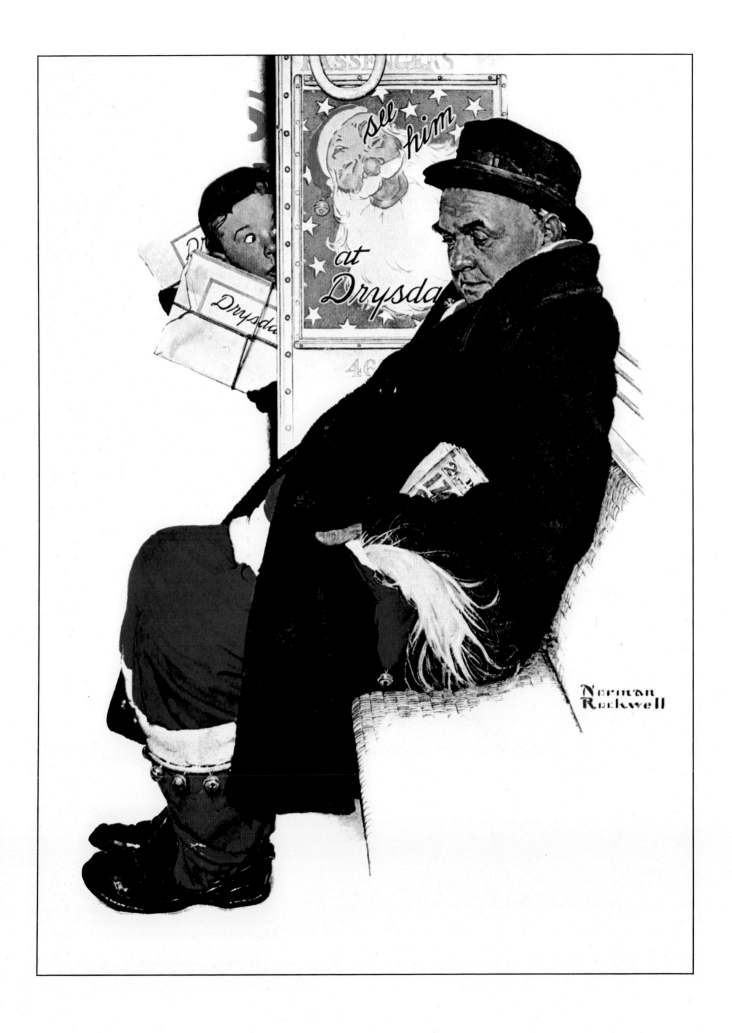

27) Santa on Subway

NORMAN ROCKWELL

THE SATURDAY EVENING POST

December 1940

Cleveland Public Library

Photo – M. Varon

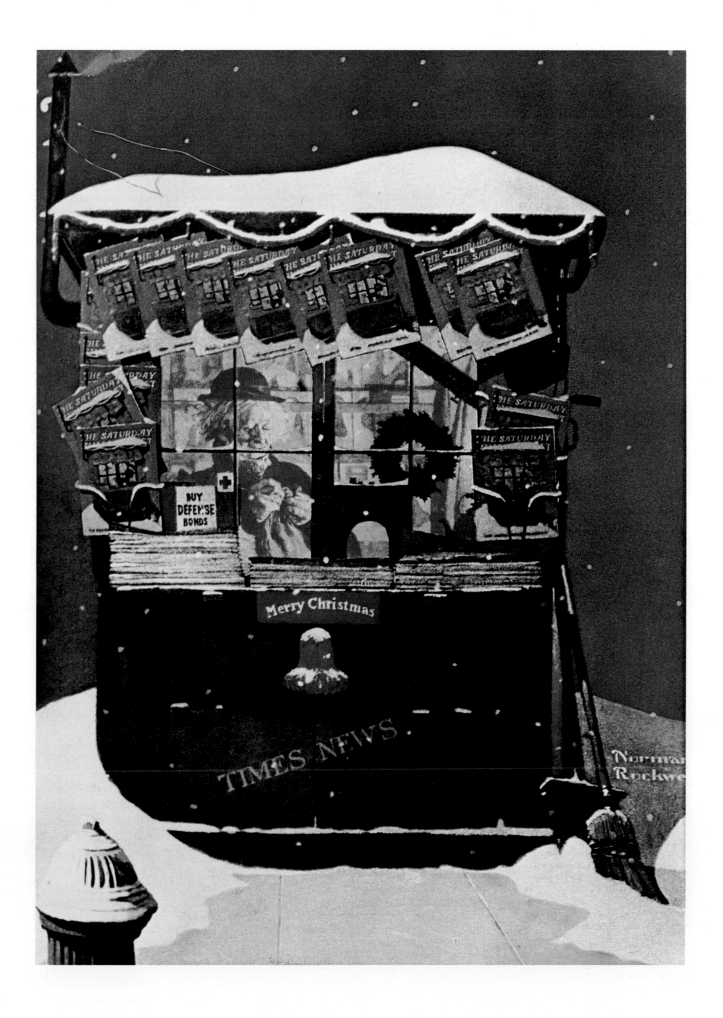

28) Newsstand

NORMAN ROCKWELL

THE SATURDAY EVENING POST

December 1941

Cleveland Public Library

Photo – M. Varon

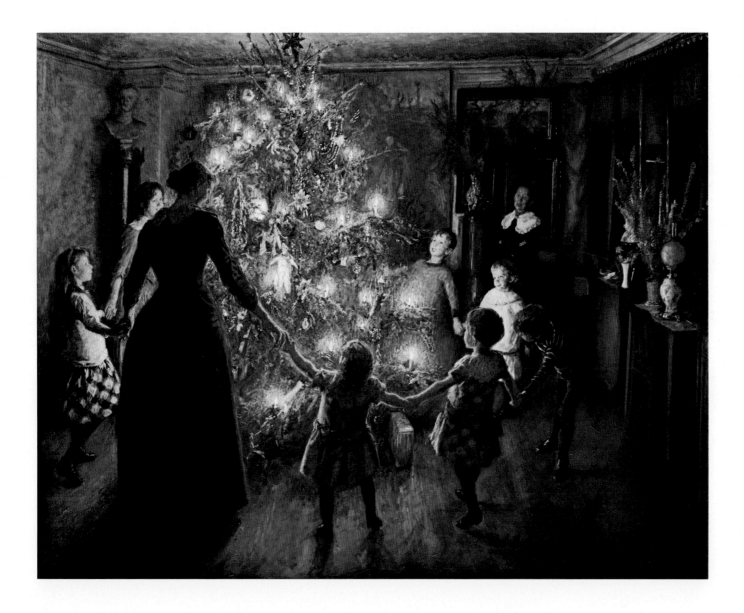

29) Glad Jul

Artist Unkown

Hirschsprung Collection

Copenhagen

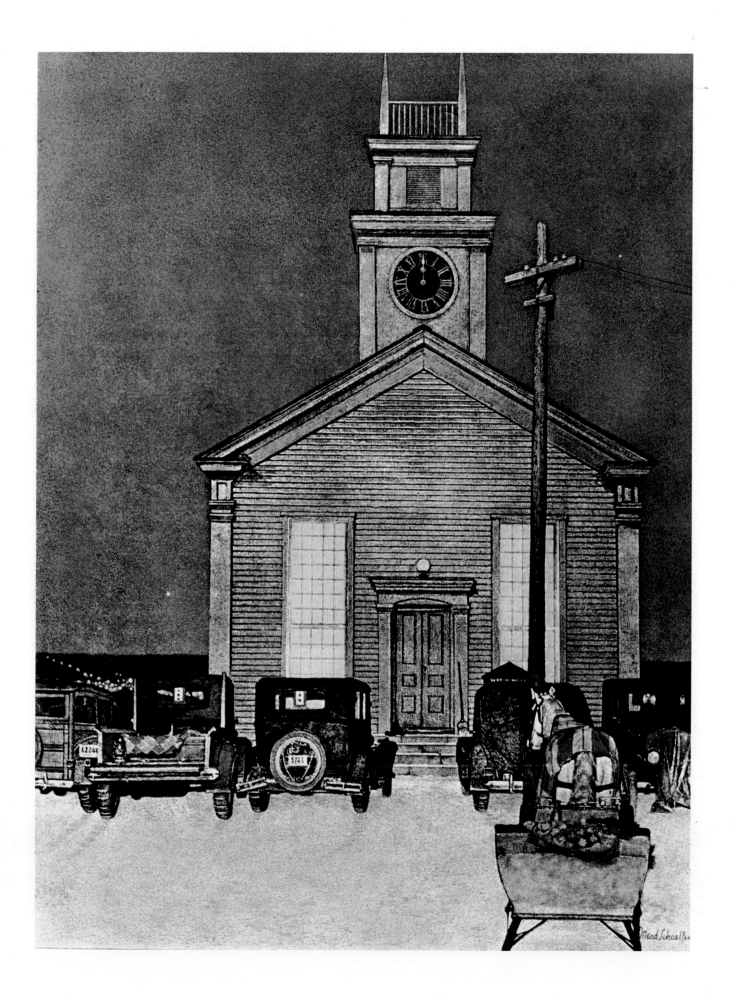

30) Watch Night Service

MEAD SCHAEFFER

THE SATURDAY EVENING POST

December 1944

Cleveland Public Library

Photo – M. Varon

Reprinted with permission from
THE SATURDAY EVENING POST
© 1944 The Curtis Publishing Company

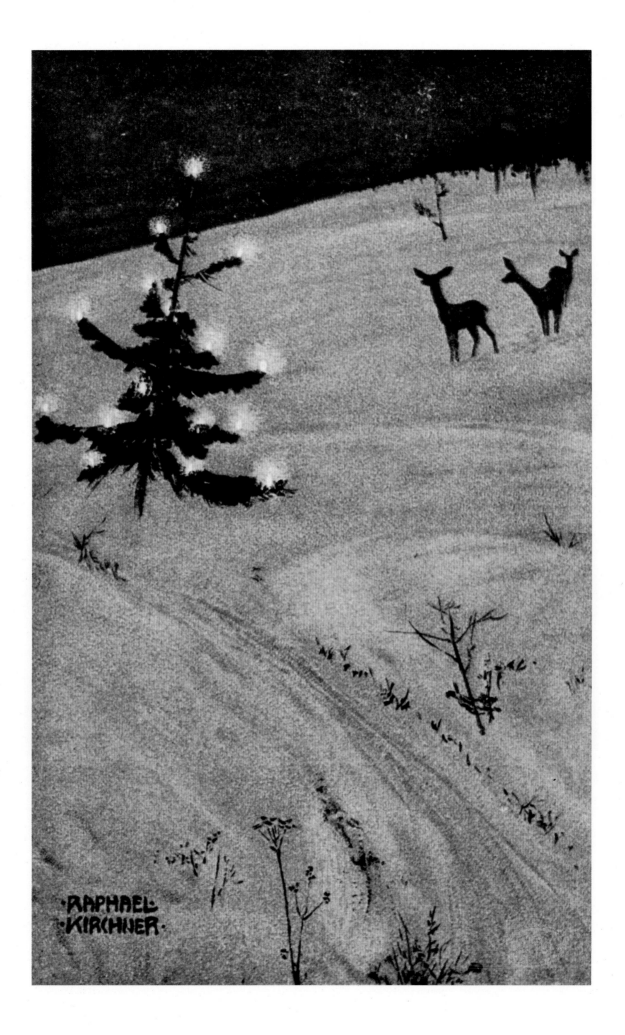

31) Christmas Landscape.
RAPHAEL KIRCHNER
Arts Decoratifs, Paris
Photo – Jean-Loup Charmet

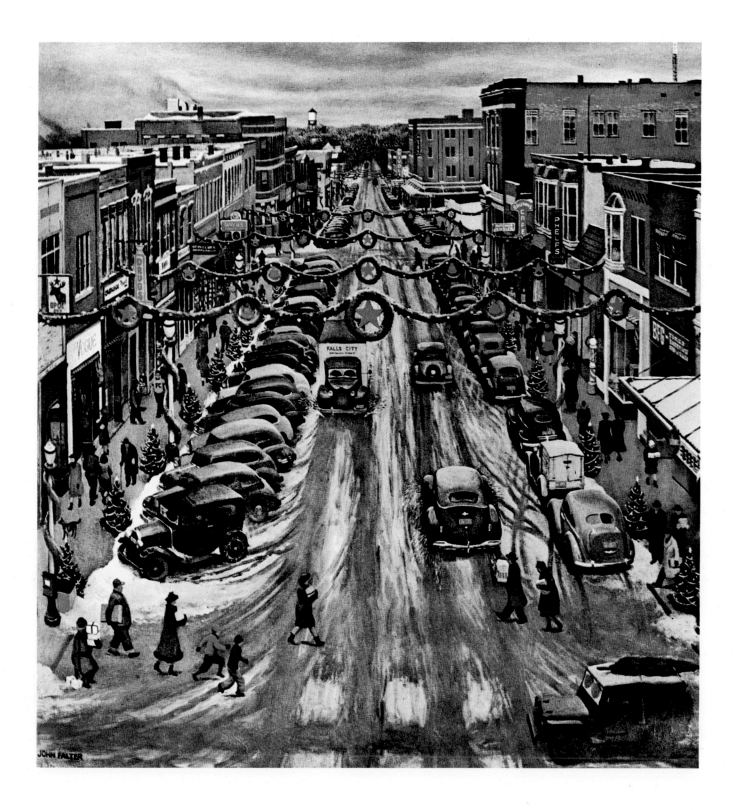

32) Falls City, Nebraska

JOHN FALTER

THE SATURDAY EVENING POST

December 1946

Cleveland Public Library

Photo — M. Varon

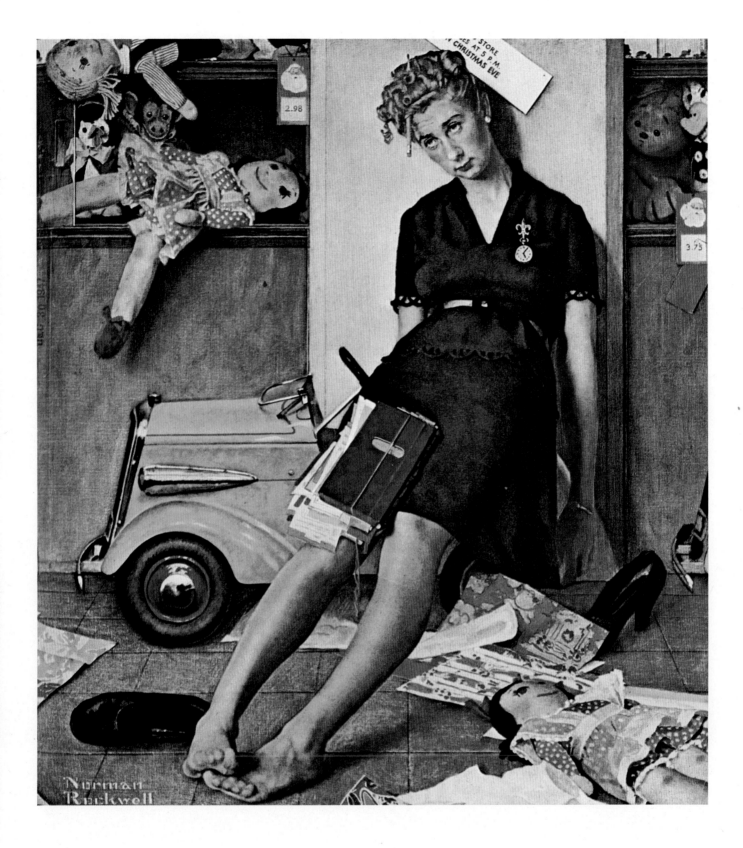

33) Worn Out Salesgirl

NORMAN ROCKWELL

THE SATURDAY EVENING POST

December 1947

Cleveland Public Library

Photo – M. Varon

Reprinted with permission from
THE SATURDAY EVENING POST

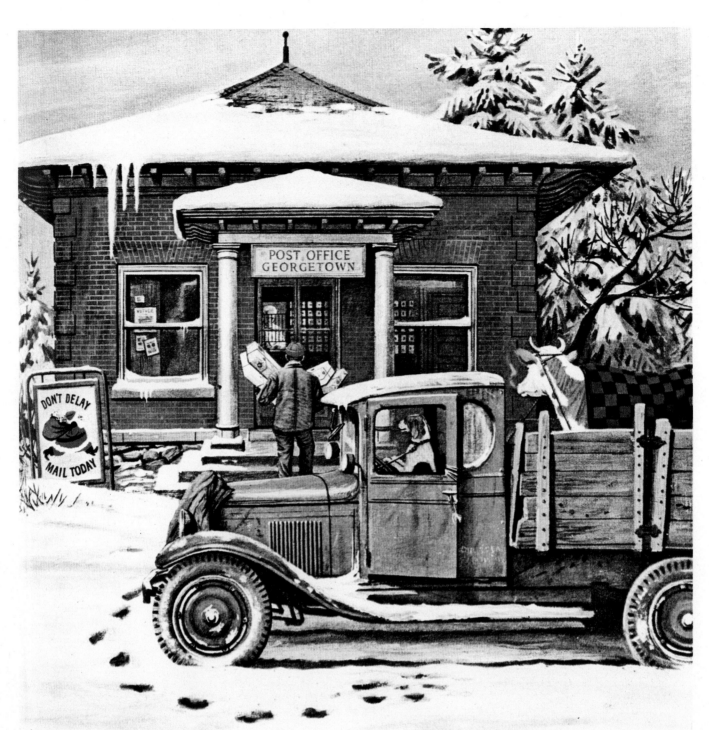

34) Georgetown Post Office
STEVAN DOHANOS
THE SATURDAY EVENING POST
December 1947

Cleveland Public Library

Photo – M. Varon

Reprinted with permission from
THE SATURDAY EVENING POST
© 1947 The Curtis Publishing Company

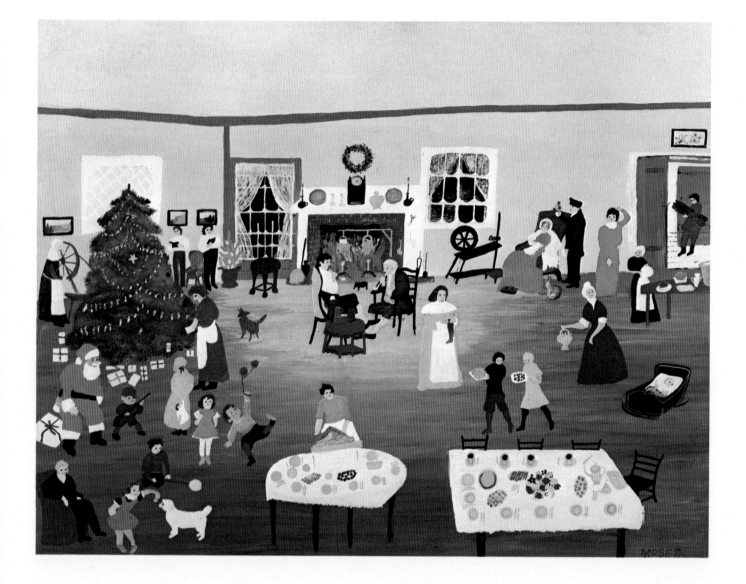

35) Christmas at Home
GRANDMA MOSES
Grandma Moses Property, Inc., New York

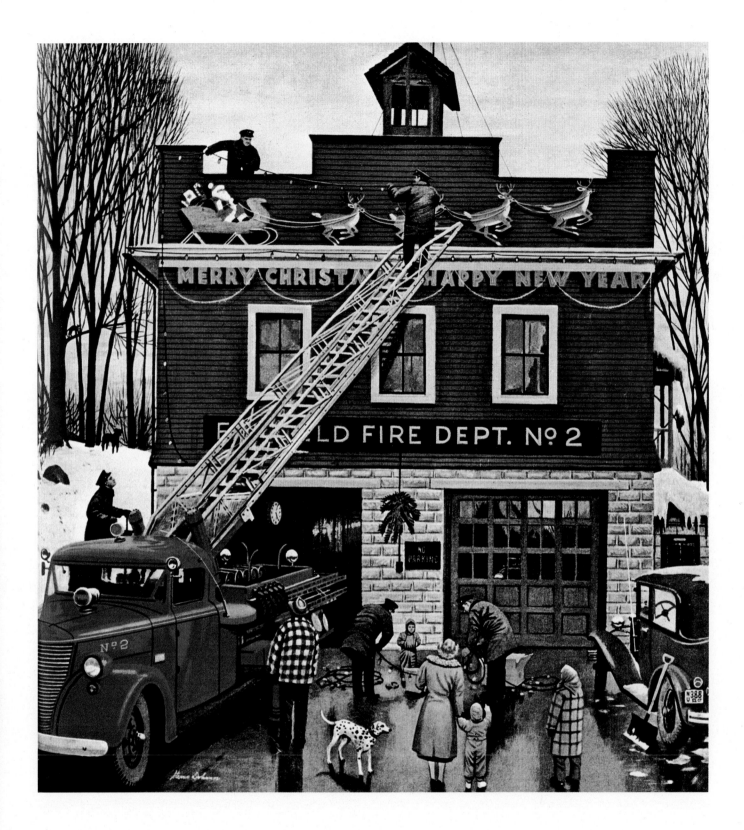

36) Fairfield Fire Department

STEVAN DOHANOS

THE SATURDAY EVENING POST

December 1950

Cleveland Public Library

Photo – M. Varon

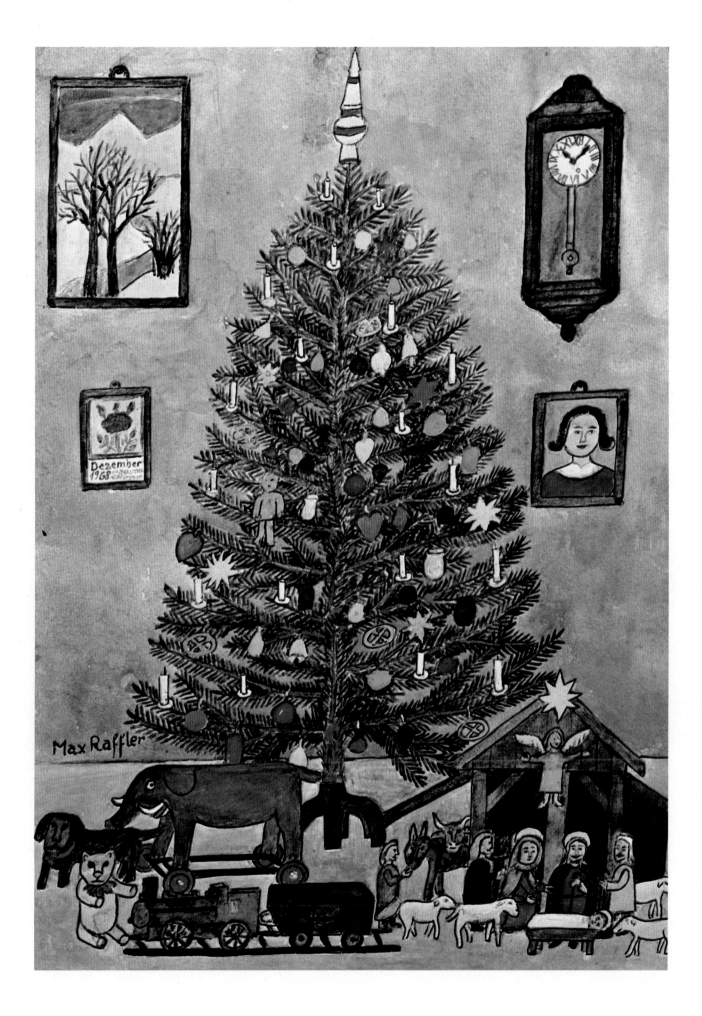

37) Child's Drawing: The Christmas Tree
MAX RAFFLER
Photo – Hansmann, Munich

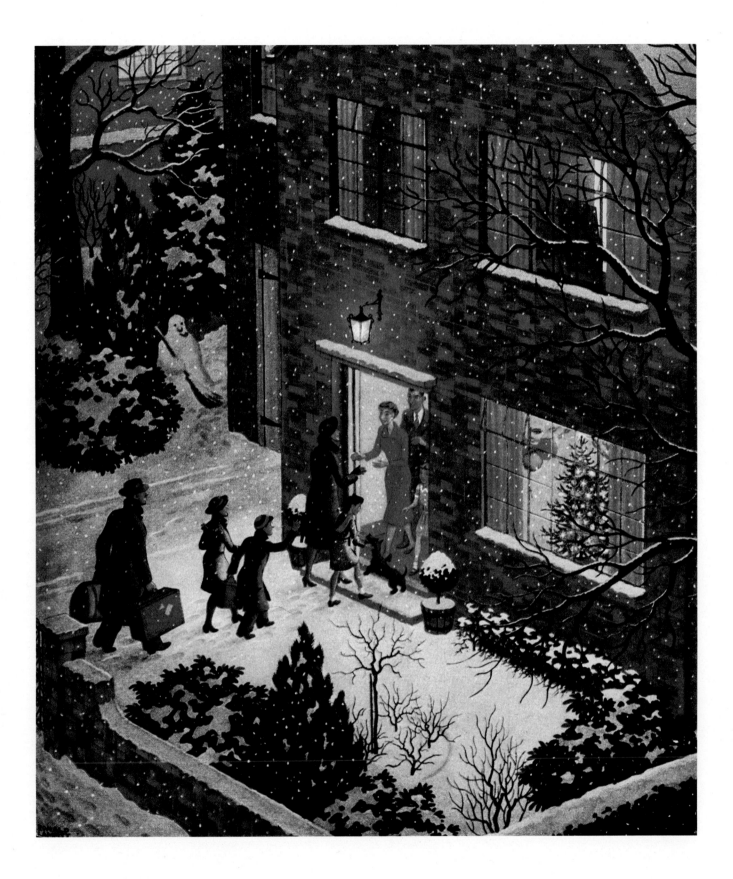

38) Christmas Visitors
RONALD LAMPITT
JOHN BULL
December 1951
IPC Publishers, London
Photo – M. Slingsby

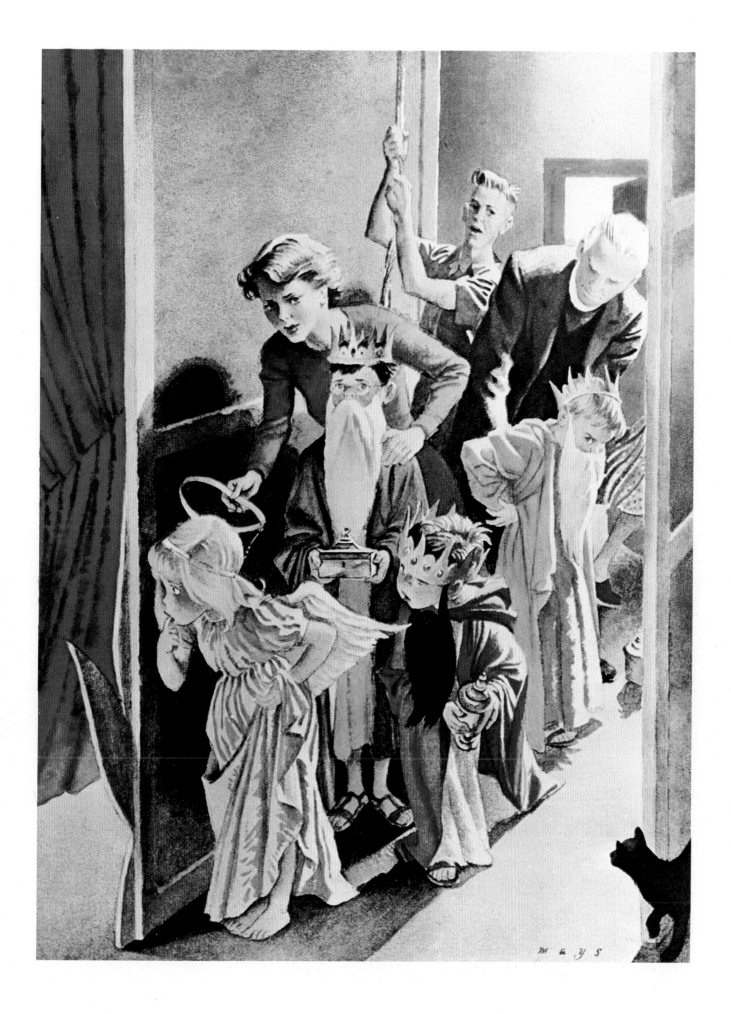

39) Christmas Pageant
MAYS
JOHN BULL
December 1952
IPC Publishers, London
Photo – M. Slingsby

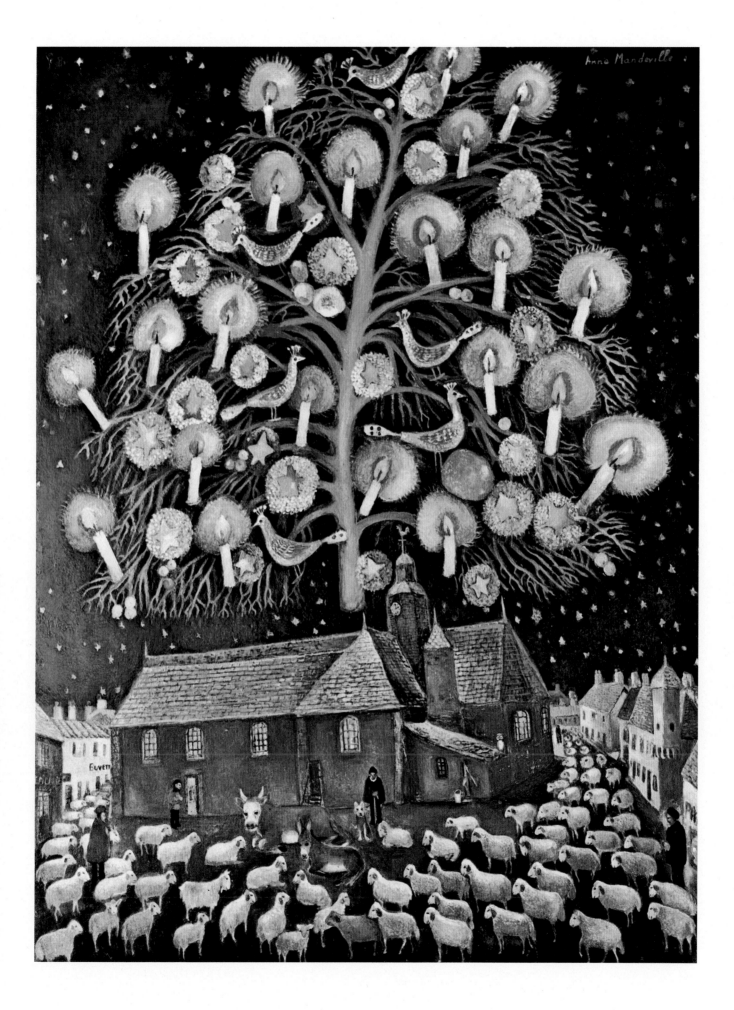

40) The Marvellous Eve
ANNE MANDEVILLE
1972
The Artist's Collection, France